工頭 愛 小叔

LOVE
is
YOU + ME

圖・文―――小叔

英譯 ―― 李偉台

目次

chapter

3

chapter

6

chapter

7

角色介紹
Character introduction

Character introduction
Kong

工頭哥

Sometimes talks too much with old friends

Usually doesn't know what to say with new friends

Feels blue sometimes

Dancing weird when happy

Enjoy reading heavy hard copy books

He's my funny valentine

工頭 愛 小叔

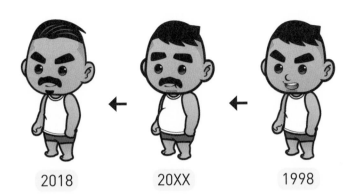

2018 ← 20XX ← 1998

面對老朋友
有時話太多

面對新朋友
大半時候
會像啞巴

開心時
會跳一段奇怪的舞蹈

偶爾會有點
小低潮

非常喜歡看
又厚又重的書

他是我心中
的怪怪天菜

Uncle

角色介紹

小叔

Coffeeholic

Addicted to Netflix

Foodie

Enjoy singing very much

I'm an illustrator with wide interests

工頭 愛 小叔

012

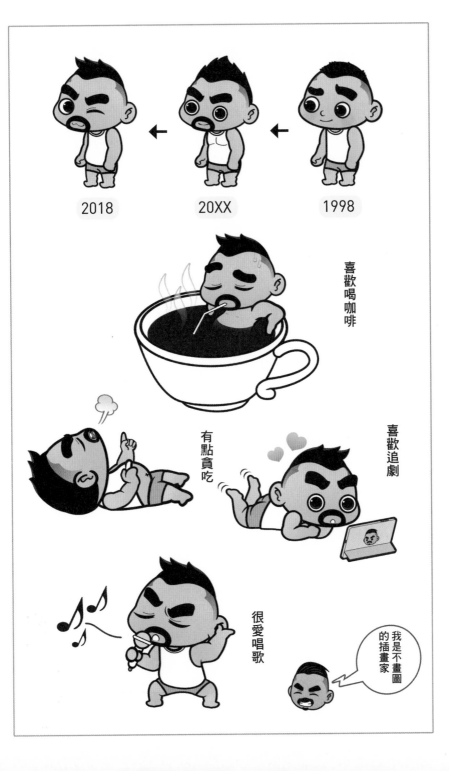

chapter

The Night

那一晚

You had me even before we started a conversation.

And that was the reason why I approached you.

Everything was so great that it felt like we've known each other for a long time.

But we still had to say goodbye.

Thank you for the invitation but I don't think I could have more drinks later.

Oh, okay. Maybe next time.

小叔
工頭
愛

016

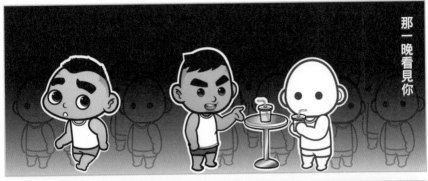

那一晚看見你

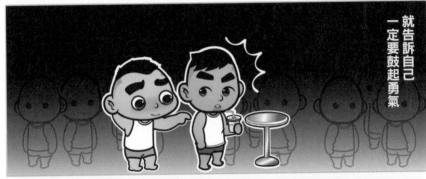

就告訴自己
一定要鼓起勇氣

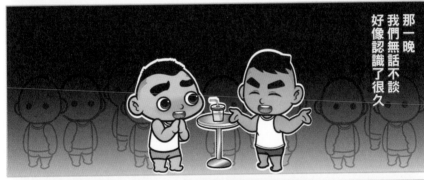

那一晚
我們無話不談
好像認識了很久

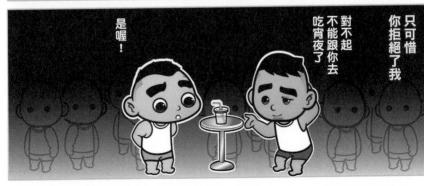

只可惜
你拒絕了我

對不起
不能跟你去
吃宵夜了

是喔!

Though you gave me your number before you left.

This is my pager's number.

Cool, thanks. Keep in touch!

I still felt a little down however.

Eventually you ran to me

Wait!

And that was how our story began.

Oh. I almost forgot my correct pager number. Keep in touch!

小叔
愛
工頭

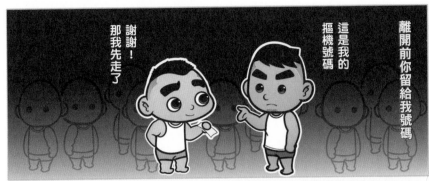

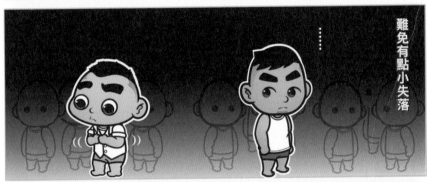

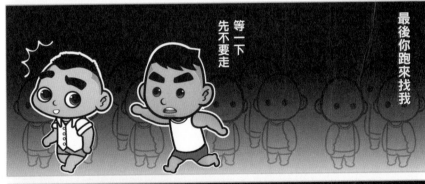

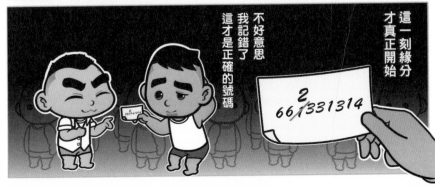

Attraction

吸
引

Why you gave me wrong number that night?

I was not sure if you are clingy or not.

So why you gave me the correct one before I left?

I couldn't resist the way you looked when you zipping up your jacket. It was so beautiful!

I knew it! I am too attractive to resist.

Oh, come on!

工頭 | 愛 | 小叔

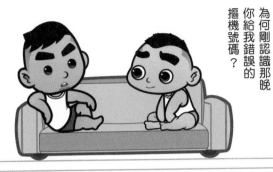

為何剛認識那晚
你給我錯誤的
摳機號碼？

我又不了解你
怕你纏著我啊！

那為何在我離開前
給了我正確的？

因為你離開前
穿外套扣釦子
很專心又仔細的樣子
很吸引我

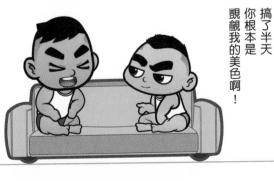

搞了半天
你根本是
覬覦我的美色啊！

哈！屁啦！

(Taking the military service) Before going back to the base...

Too much snacks to eat!

You can take them to the base.

I'll go pick you up next time. Take good care of yourself.

小
叔
_愛
工
頭

022

準備回軍營前

你也太誇張
零食太多了啦

車上吃不完
可以帶回軍營啊！

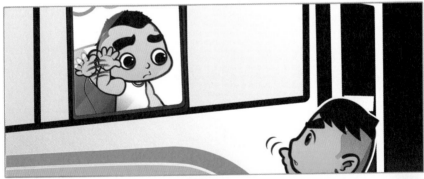

下次回來前
記得提前跟我說
我去車站接你

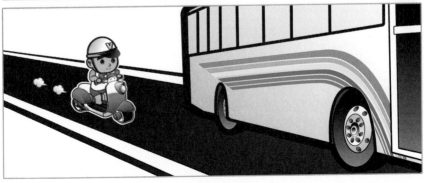

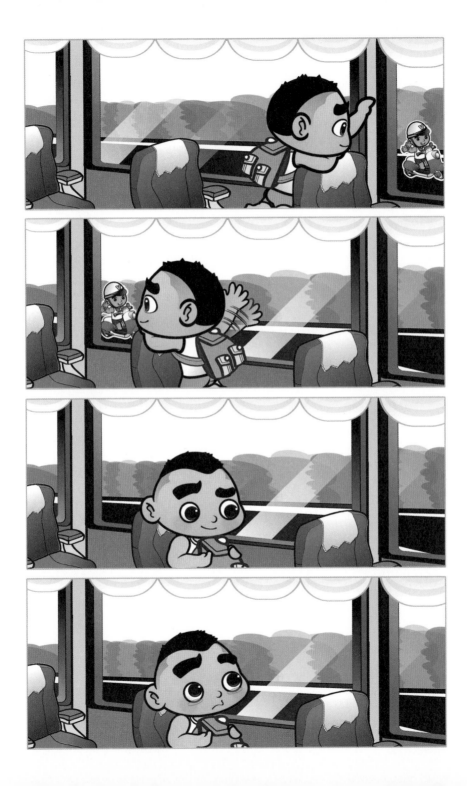

Stay Here

留下來

Thank you, I had a great time today.

Me too!

Okay, time to go home. See you next time.

Oh...

Wait! Would you stay over?

SURE!

小叔
↓
愛
工頭

026

幹嘛那麼客氣

謝謝你喔！
今天我很開心

喔……

那我回家了喔
下次見

等一下
你可不可以留下來

好啊！

Thank you for asking me to stay over here.

I... I... I am glad you said yes. Okay, have a good dream!

小叔
愛
工頭

(Next morning...)

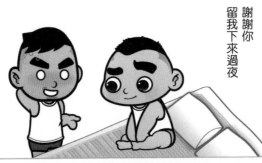

謝謝你
留我下來過夜

我……我……
我很開心啊！
你先睡
我關燈了喔！

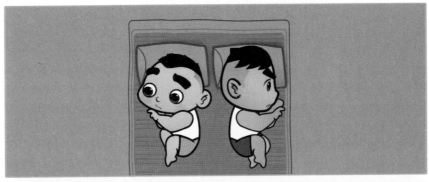

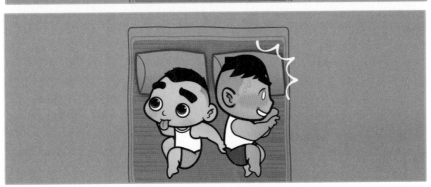

（隔天早上……）

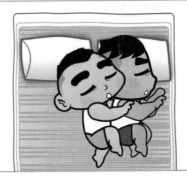

Surprise

Sweetheart, I don't have a toothbrush here, may I use yours?

Sure, and what do you want for breakfast?

Everything is fine.

Okay, wait a second.

Hooray, breakfast!

Not only breakfast and here's one more surprise for you!

Wow! A toothbrush and the key!

Yup, now here is your home as well.

寶貝
我沒帶牙刷
借你的來用喔

隨便買
我不挑食的

好喔～
那你的早餐
想吃什麼？

那我出門了
等我一下喔

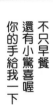
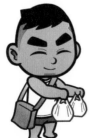

歐耶！
早餐來囉！

不只早餐
還有小驚喜喔
你的手給我一下

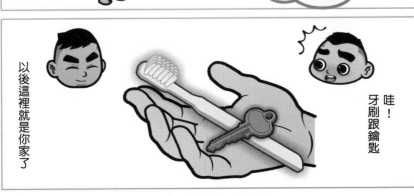

哇！
牙刷跟鑰匙

以後這裡就是你家了

Romantic Tips

製造浪漫

Sweetheart, I am going back.

Why so early? Won't you stay longer? How about having dinner together?

It's family day today, I need to attend the family gathering dinner.

Alright, let me drive you home.

Why? I can ride my scooter home.

Oh, don't you see that I just tried to seize the moment with you !

小叔
愛
工頭

寶貝我要回家了喔！

怎麼那樣快？
不待晚一點
在我家吃飯嗎？

今天家庭日
得回家聚餐啊！

那好吧！
我開車載你回去

幹嘛那樣麻煩
我有騎摩托車
可以自己回家啊！

笨喔你
我只是想多製造
一些相處的機會啊！

Poke Me

Hee, I am so excited and nervous about staying over in your place!

Hurry up, I am in a little rush!

Okay, okay~

Grrr, behave yourself! Your hands are distracting my attention.

Al~right~

And don't poke me with your prick, it's distracting as well.

Hee Hee Hee~

嘻嘻嘻
要去你家過夜耶
好緊張喔!

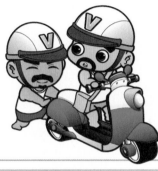

動作快一點
我趕著回家了喔!

好!好!好!

吼!手不要亂摸啦!

好咩!

也不要一直頂著我
很難專心騎車耶!

嘿嘿嘿!

剛交往

（狀態：小鮮肉）

（狀態：小鮮肉）

交往5年

（狀態：肉壯大奶）

（狀態：肥嘟嘟）

Relationship: Just Begin

Body Type: Twink

Body Type: Twink

Relationship: 5 years

Body Type: Chubby

Body Type: Muscle Macho

交往**10**年

（狀態：神豬破百）

（狀態：神豬破百）

交往**20**年

（狀態：瘦身成功）

（狀態：體重不詳）

Relationship: 10 years

Body Type: Chubby Bear

Body Type: Chubby Bear

Relationship: 20 years

Body Type: Unknown

Body Type: Well-Built

chapter

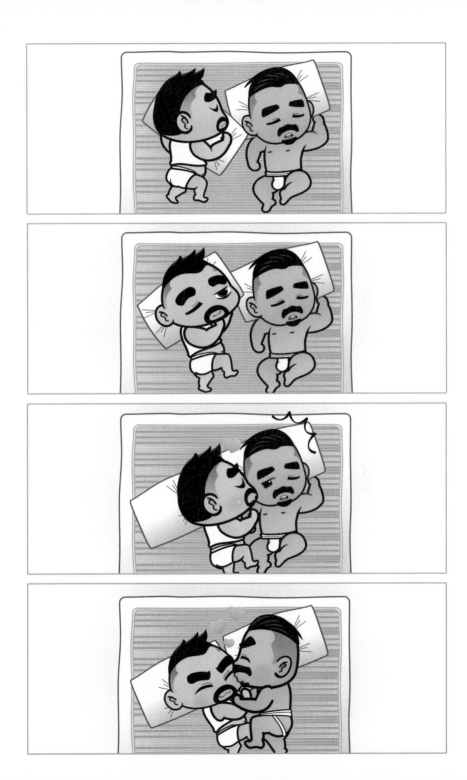

DIY Master

Oh, what are you making?

You will know later sweetheart!

Wow, you are my DIY master!

Ha Ha Ha! Look, a folding table!

Okay... not so perfect as my expectation.

Well...

And since then... (Why you still keep it?)

工頭
愛
小叔

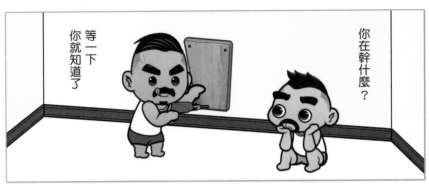

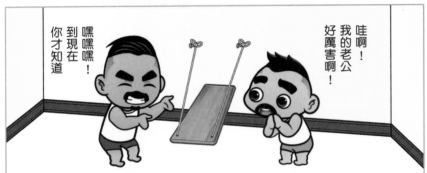

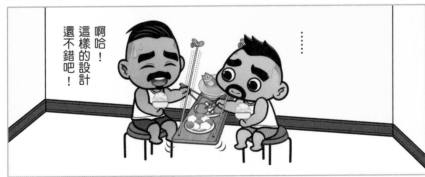

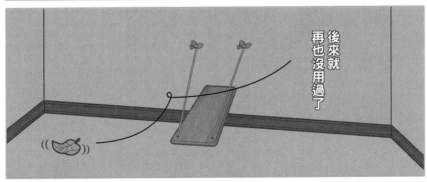

Horror Movie

恐怖片

Why you insist on seeing this movie?

It's the hottest horror movie on Rotten Tomatoes!

It's so embarrassing, take me home, NOW!

I will never doubt about the reviews on Rotten Tomatoes!

小叔
愛
工
頭

為什麼一定要看這部電影？

這是目前網路推薦必看的恐怖片啊！

......　......

哇哇哇哇
WOW WOW
WOW
哇！
哇
WOW

好丟臉喔！快帶我回家

這一場真的值回票價啊！

Sweetheart, what are you doing?

Oh, I am enjoying my afternoon tea.

Sweetheart, what are you doing?

Shopping, shopping and shopping.

Sweetheart, what are you doing?

Netflixing and fried chicken. (And a can of beer of course)

It seems that you do enjoy life without me, don't you?

You idiot! I just wanna enjoy my life when you are not around
me. Nothing compares to the happiness being with you.

工頭 愛 小叔

044

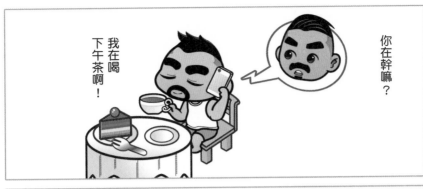
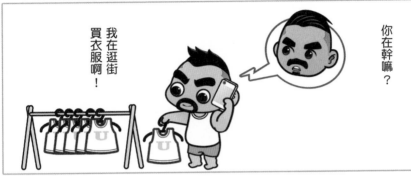
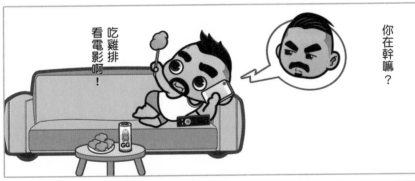
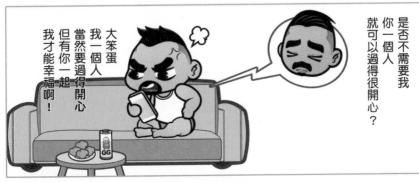

Itchy Ass

屁股癢

Is there anything you wanna tell me or just your ass is itchy?

I want an arms carry. (blush~)

No problem my sweetheart.

OH YES! My hero, give me more!

More than that, let's try the suspended congress as your bonus!

Ah, I think you should start on your diet first. (Waist pain)

Um... That's definitely not my problem.

小叔
工愛
頭叔

046

Big-Boned

骨架大

It's must be something wrong with the scale!

I told you that you should start on a diet one thousand years ago!

Gosh! Dumbo is approaching!

How dare you!

You are choking me!

Don't call me Dumbo, I am just big-boned!

小叔
愛
工叔
頭

哇咧！

哈哈哈！
胖子該減肥了

嘩嗟！

靠！
豬飛起來了！

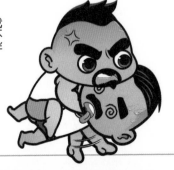

我不胖
我只是骨架大

咳咳！
謀殺親夫啊！

Your Belly

你的肚子

Firstly, your belly comes from too much bubble tea.

Secondly, your belly comes from too many chips.

Thirdly, your belly comes from too many ice sticks.

But come in all, your belly is one of the reasons I love you so.

小叔
愛
工頭

你的肚子
就是猛喝飲料
變大的

你的肚子
就是亂吃零食
變大的

你的肚子
就是狂吃冰棒
變大的

你的肚子
就是全世界
我最愛的枕頭

Let me try your cake.

Let me try your chips.

NO! NO! NO! Not this time! You have yours, don't eat mine!

Okay, you have yours, I EAT MINE!

小_愛叔
工頭

我要吃
你的蛋糕

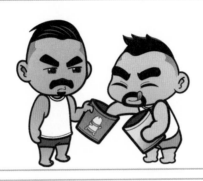

我要吃
你的洋芋片

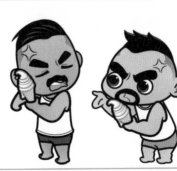

這次我不給
真的是壞習慣
吃你自己的啦！

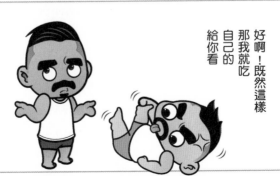

好啊！既然這樣
那我就吃
自己的
給你看

Selfie

自拍

Sweetheart, it's beautiful here. Let's take a selfie!

Ready? THREE, TWO, ONE!

CHU~

I love this one!

So do I!

小叔
愛
工頭

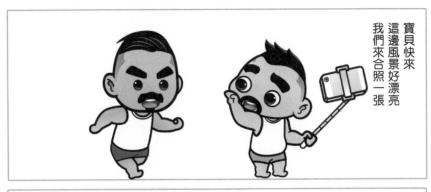

寶貝快來
這邊風景好漂亮
我們來合照一張

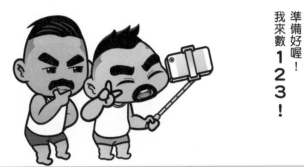

準備好喔！
我來數 **1 2 3**！

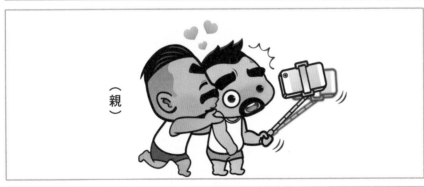

（親）

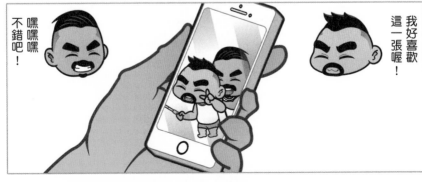

我好喜歡
這一張喔！

嘿嘿嘿
不錯吧！

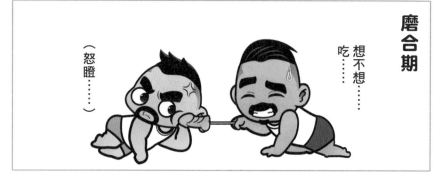

The Infatuation Stage

Would you... like... some...hot creampie?

Um... SURE!

The Understanding Stage

Would you... like some...

(AN ANGRY STARE)

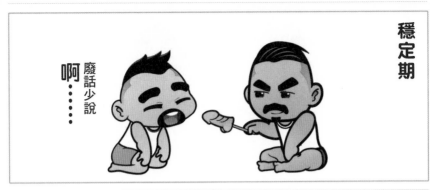

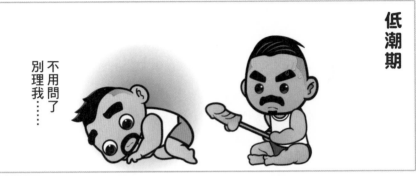

The Stability Stage

Duh! Just come feed me!

The "I have no mood" Stage

Not today......

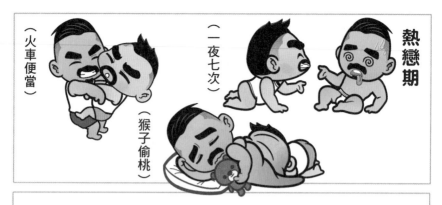

The Infatuation Stage

Feed me! More and more!

Lick, lick, who's there?

Suspended congress

The Understanding Stage

Sit! (whipping)

Hey, stop! IT HURTS!

The stability Stage

Ah, feels so good! (fart)

Uggh~~~

The "I have no mood" Stage

How about...?

NO WAY!

chapter

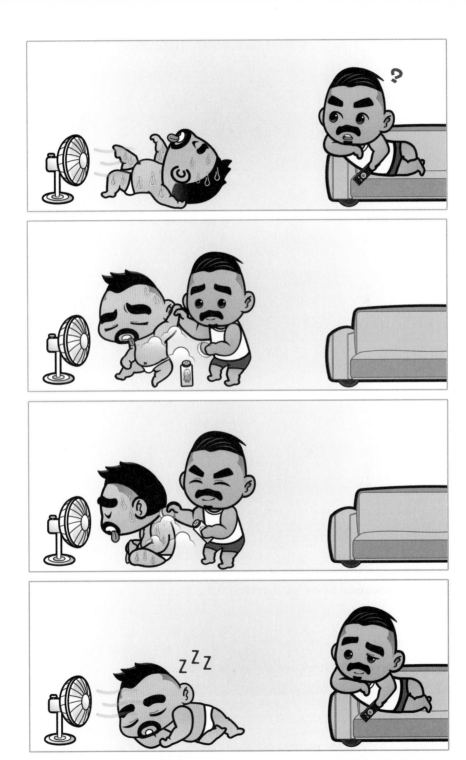

The Benefits
of Gay Couples

男男伴侶的好處

ONE: More choices of color for your clothing

How about I take the red one and you take the white one?

Actually, I know you like the white one, don't you?

TWO: More choices of flavor for your dessert

I want to eat yours.

I am sure you are not just meaning the ice cream.

THREE: More romantic atmosphere in your daily life.

Take it off, that is my new AUSSIEBUM!

Come on, you wore my new ANDREW CHRISTIAN as well !

FOUR: More passion and warm in winter.

小叔
愛
工頭

衣服多一種顏色

我買紅色
你買白色
好不好？

你喜歡白色
對不對？

甜點多一種口味

我還想
吃你那支

上面還是
下面那支啊？

生活多一點情趣

幹嘛穿我的
給我脫下乃

吼！
借我穿一下
會死喔？

冬天多一點溫暖

Indecisive

哪
件
好

Which one is better?

Both are fine! Just quick or we will be late!

Yes I know both are fine thus I need your opinion.

Um... Okay, the yellow one.

Well... I still think the white one is better.

Grrrr... I knew it! Go change it, hurry!

I love you sweetheart!

Unhuh, we are late... again!

小
工 愛 叔
頭

哪一件我穿起來比較好看？

隨便啦！快點做決定不然要遲到了

可是兩件我都覺得還不錯耶！

別再猶豫了就黃色那件吧！

我......我可以換成白色的嗎？

吼！我就知道快去換啦！

嘻嘻！

每次都這樣要遲到了啦！

Hey sweetheart, anything wrong?

Nope...

Okay, I will leave you alone.

I need some space.

Few Days Later...

Are you done?

What are you looking for? You just left.

Don't ignore me, I don't wanna be all by myself anymore.

工頭小叔愛

寶貝你怎麼了？

沒事……

那我就不吵你了喔！

別煩我……

幾天後……

你到底想怎樣
搞自閉嗎？

你還來幹什麼
你不是不管我了嗎？

不要不理我
別讓我覺得我
只有一個人

Break Up

說分手

So you want to break up?

Okay, as your wish!

Few Days Later...

I'll cook tonight, come back for dinner!

SURE! T_T

I miss you so much! T_T

Sorry, I will never say that again!

小叔
愛
工頭

068

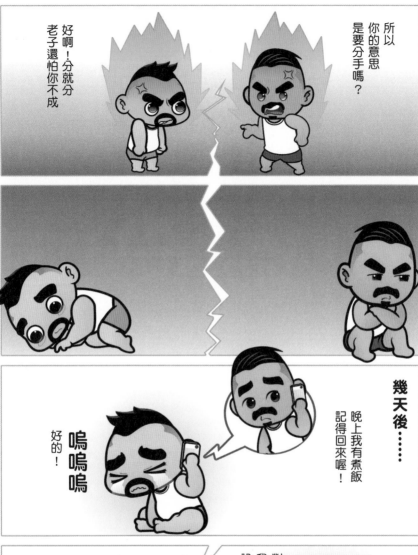
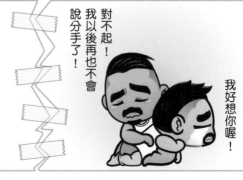

Synchronism

默契

Synchronism is

When two people

Think of

Why are you leering at me?

You know why!

The same thing

Okay, lay down and be my prey!

Wait, it's YOUR TURN!

小叔
工頭

「默契」是

兩個人

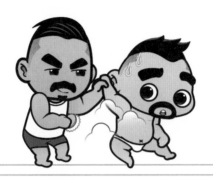

腦袋想的

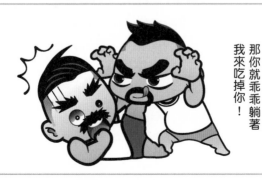

跟對方一樣

AHHH! Cockroach!

No worry sweetheart, let me finish it!

You are safe now! Give your knight a kiss.

Wait! Did you wash your hands already?

工頭｜愛｜小叔

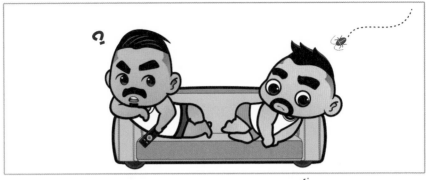

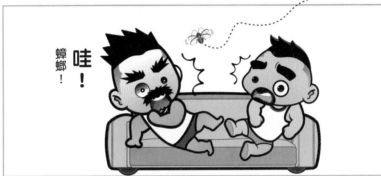

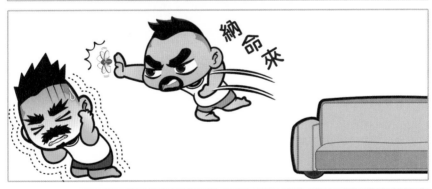

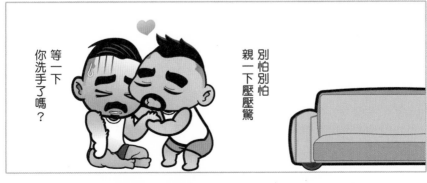

Split

劈腿

No, I didn't mean you cheated on me. This is just a warning. Don't try to cheat on me.

Why you just can not believe that I will never cheat on you?

Alright, do a split right now right and I will apologize for having doubts about you.

What a fucking stupid request! Open your eyes and watch carefully!By doing this split, I am here to show my loyalty to you.

I hit my balls, would you help to stand up?

工頭_愛小叔

074

我沒懷疑你
我只是警告你
不要輕易劈腿

說到底
你就是
不相信我

好啊！
有種你現在
就劈腿看看

哼！
還怕你不成

看清楚喔！
超級大劈腿

我⋯⋯我⋯⋯
撞到蛋蛋了
快拉我起來

Size Matters

比大小

Tell me the truth. What is the biggest dick you ever experienced?

Come on, it's very rude to ask about this!

Just answer my question!

Ok, I am showing you! Come check how big my mouth is opening.

How about mine?

As your size...

Hey, that's not funny! Don't look me down!

小叔
愛
工頭

我問你
老實回答喔！
你吃過的腸腸中
最粗的有多大？

哪有問得這麼直接啦！

不敢對我說
實話喔

像嘴巴這樣大啊
自己看**啊**！

那你比看看
我的有多大啊！

啊……

屁啦！
哪有那麼小？

Hello, I would like to order 2 servings of sausage with sticky rice.

And I want 2 skewers of chicken butts.

Yup, and 1 pearl bubble milk tea... no ice with quarter sugar.

I would like to order 1 sugar free cold Oolong Tea!

It's very impolite and annoying to interrupt the conversation. Would you please stop doing that?

You will regret saying that to me! I will eat all things you ordered and you will have nothing to eat!

What a crazy way to take revenge!

小叔
工頭

078

老闆你好
我想點兩份
大腸包小腸

我要點
雞屁股兩串

還要一杯
微糖去冰的
波霸珍珠奶茶

我我我
要點無糖的
冷泡茶

很煩耶！
你在外面
是不是也一樣
愛亂插嘴？

氣死我了！
居然這樣說我
太可惡了！

我向來
只插你的嘴
從來沒插過
外面的

噁！

My lovely fatty, are you ready to experience the ultra unforgettable food organism?

Sounds attractive but you just mentioned I need to on a diet, right?

But this is the fried chicken I bought from your favorite shop!

No way!

Hey, okay, a small bite is fine!

Stop teasing me!

10 minutes later...

You ate them ALL? Are you sure you are on a diet?

Well, I can start it tomorrow.

工頭 小叔

080

胖子
要不要吃
墮落食物啊？

不要啦！
最近太胖了
要控制一下

這雞排超有名
我特別去排隊
排了半小時才買到耶！

我不要！

好啦！
我出去一下
想吃自己拿喔！

（我不聽！我不聽！）

十分鐘後……

死胖子
你不是堅持不吃嗎？

唉……
這個嘛……

Couple's Weekends

週末日常

Hanging out together

Hee!

Grrr... behave yourself!

Peeping cute guys together

He looks cute!

Hello guys, wanna some juicy saussages?

Gourmet hunting together

More roasted chicken butts? That's your favorite.

I had a lot of it today. (Burp~)

Making love together

Oh, Oh, I drank a little bit too much. I am not hard enough.

That's not a problem, I am full hard now!

小叔
工頭

唏唏唏！

唉唷！
別亂摸啦！

老闆很可口喔！

真的耶！

兩位帥哥
想吃點什麼
盡量點

下半身
燒烤

給你！
你最愛的屁股！

不用！
我今天吃很多了

GG

晚上酒喝太多
不夠硬捏！

那有啥關係
我已經硬硬 der 了喔！

Fart

屁
啦

Manner, please!

O~~~K~~~

That was quite rude.

I just couldn't hold it!

Oh, holy shit!

Never think about I will give you a rim job!

Why so serious, Grumpy?

小
愛叔
工
頭

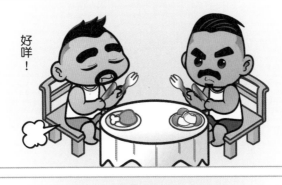

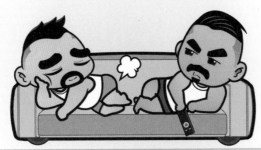

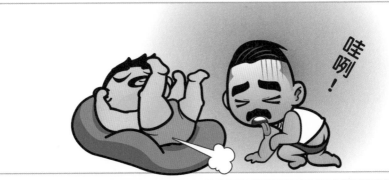

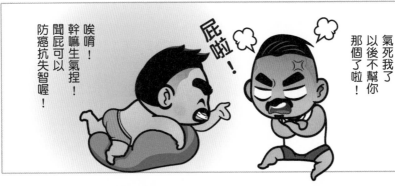

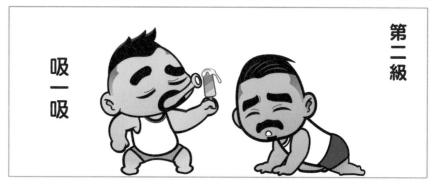

吃棒棒教學1

第一級

舔一舔

第二級

吸一吸

Ways to Enjoy Oral Sex I

LEVEL ONE

Lick it, feel how hard it is.

LEVEL TWO

Suck it, feel how long it is.

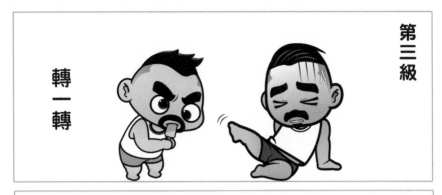

第三級　轉一轉

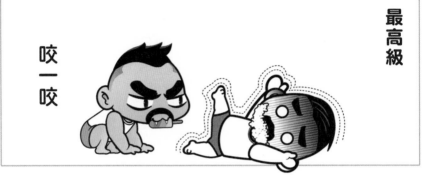

最高級　咬一咬

LEVEL THREE

Tongue it, feel how juicy it is.

LEVEL FOUR

Bite it, call 911 please!

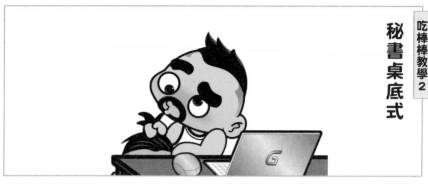

秘書桌底式

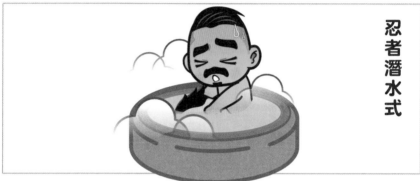

忍者潛水式

吃棒棒教學2

Ways to Enjoy Oral Sex II

The 'Please go down my working table' Style

The 'Ninja assassin' Style

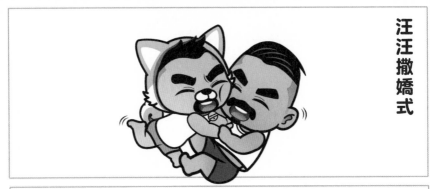

汪汪撒嬌式

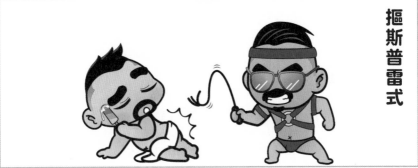

摳斯普雷式

The 'Lassie Come Home' Style

The 'Worship your master' Style

chapter

Perfect Couple

完美伴侶

May I ask a question?

Yes, please.

What is the definition of perfect couple?

Good shot! Firsly, you two need to be perfect match in sex. Secondly, you two need to have common interests.

Perfect match in sex makes you two as FWB.

Common interests make you two as BFF.

But once you two are perfect match in sex and have common interests, that make you two a perfect couple.

小叔
愛
工頭

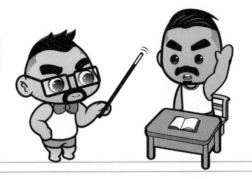

老師！
我有一個問題

工頭同學
請說！

兩個人
在什麼狀況下
才能算是在一起呢？

這個問老師就對了
一要能 **上床**
二要能 **聊天**

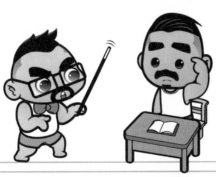

只能上床是 **炮友**
只能聊天是 **閨蜜**

兩個都可以就是
註定在一起

Sweetheart, I need to make a confession...

Confession? Why don't you go to church?

Promise that you will forgive me no matter what I did.

I tried to resist but I couldn't help myself...

Love relies on we trust each other. Tell me what happened and you know I love you.

I was so hungry last night and I ate all sausages you bought from your favorite shop!

You are too dramatic, sweetheart.

小叔
工頭
愛

096

寶貝！我問你喔？

幹嘛這樣怪里怪氣的？

如果我偷吃了你可以別生氣嗎？

我一不注意就忘了控制自己！

唉！我們居然也走到了這一步！你就跟我實話實說吧！

昨晚太餓了把你最愛的香腸統統吃光了！

靠！害我以為……

Like vs. Love

喜歡和愛

What's the difference between 'like' and 'love'?

You will show the best of yourself when you 'like' someone.

You will be yourself when you 'love' someone.

(fart)

Well, thank you for proving it but maybe don't love me this much?

Now you know how much I love you!

小叔
愛
工頭

喜歡 跟 愛
有什麼不同？

喜歡 一個人
你會在對方面前
表現出最好的自己

愛上一個人
你能在對方面前
表現最真實的自己

唉呦！
控制不住咩！

好啦！好啦！
我知道你很愛我啦！

Love's Like
Playing a Seesaw

愛的翹翹板

You may get hurt if you play too hard.

Someone may feel boring then go away.

Someone may want to take your place.

Once you find the proper tempo and mate, you will love it forever.

小叔
工頭
愛

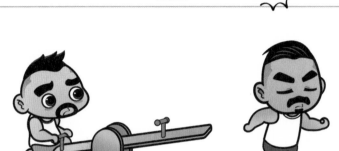

感情就像翹翹板
太激烈有人會受傷

有人玩到一半
覺得無聊
就不玩了

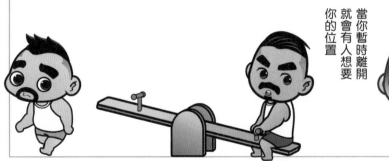

當你暫時離開
就會有人想要
你的位置

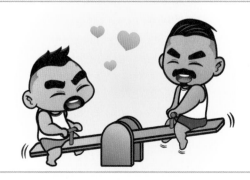

一旦找到了
節奏與默契
就再也捨不得離開了！

Communication

溝
通

The most important thing of communication is the 'attitude'.

And of course, don't forget the importance of 'listening'.

Yelling is not a good way.

Not to mention shouting each other.

小
叔
愛

工
頭

溝通
最重要的是
頻率一致

前提
雙方都要
打開耳朵

大吼
對方不願聽
也聽不懂

互相大吼
雙方都不願聽
也聽不懂

What a hot day! (Turn on the fan)

OOPS~~~

What are you hiding?

I did a sketch of you. Don't laugh at me, I tried, okay?

Ha ha ha! I will never forget this in the rest of my life.

小叔
工頭
^愛

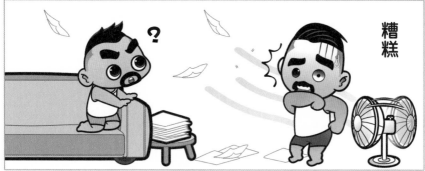
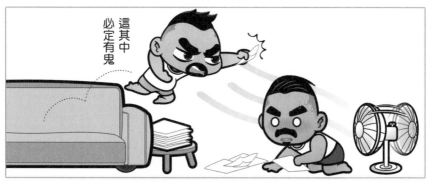
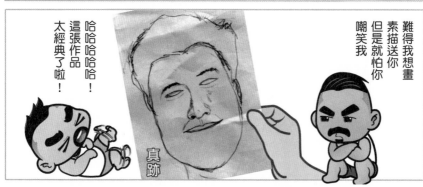

Daily Little Things

點
點
滴
滴

Having a rest under a shadow to make you feel cooler while waiting the traffic lights.

Protecting you from the rain.

Buying your favorite drink when you are thirsty.

Happiness comes from the daily little things.

Let's saving out travel fund together!

Sure, I can't wait to travel with you!

工頭｜小叔
愛

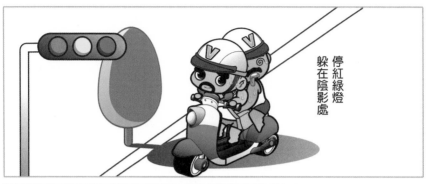

停紅綠燈
躲在陰影處

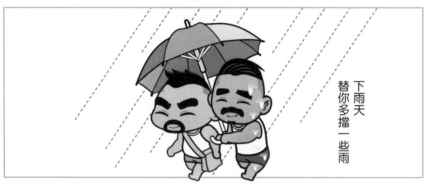

下雨天
替你多擋一些雨

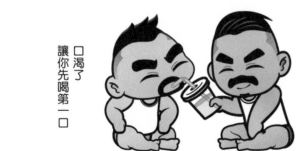

口渴了
讓你先喝第一口

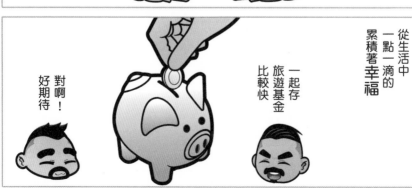

從生活中
一點一滴的
累積著幸福

一起存
旅遊基金
比較快

對啊！
好期待

I am not sure if I can go. I will call you back after I ask him.

Something wrong with my ex's computer, I am going his place to check it.

Okay, don't take too long.

You sure? No jealous?

Should I? I think a stable relationship is based on trusting each other.

工頭 愛 小叔

Thank you for trusting me.

108

我現在沒辦法
答應你
我先問過他
再說！

嗯嗯！
別太晚
回來喔

我前男友
電腦壞了
我去幫他修理喔！

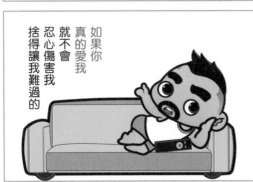

如果你
真的愛我
就不會
忍心傷害我
捨得讓我難過的

你不會吃醋嗎？
不擔心我
趁機會去亂搞喔？

怎麼捨得
讓你難過呢！

Save Face

Sweetheart, would you ask back together if someday we break up?

Yes I would absolutely.

Why you are so sure?

I know you always want to save face, so I will do that.

You are so thoughtful!

小叔
愛
工叔
頭

110

寶貝
問你喔
假如有一天
我們分手了
你會回來
找我嗎？

當然會啊！

誰曉得
你是不是
隨便說說！

因為某人愛面子
怕找不到台階下
所以我一定會
找你回來

好喔！
那一言為定

Some Puns
for More Fun!

愛的暗號

Let's Start!

I am starving! I need some creampie!

Do you want to try a money shot?

Would you like some meat popsicle?

Just let it melts in my mouth!

Don't spit, just swallow!

I am ready to get dirty.

Which hole need to be drilled?

The plumber is ready to get his pipe cleaned.

Try the back door.

Go suck myself!

I know one easy way to know your size...

Let's try a new position tonight!

Glow in the dark.

Can I stick it in your mouth?

Eat my mushroom, it's your favorite!

AH~~~

Suspended congress

Can I have more sausages?

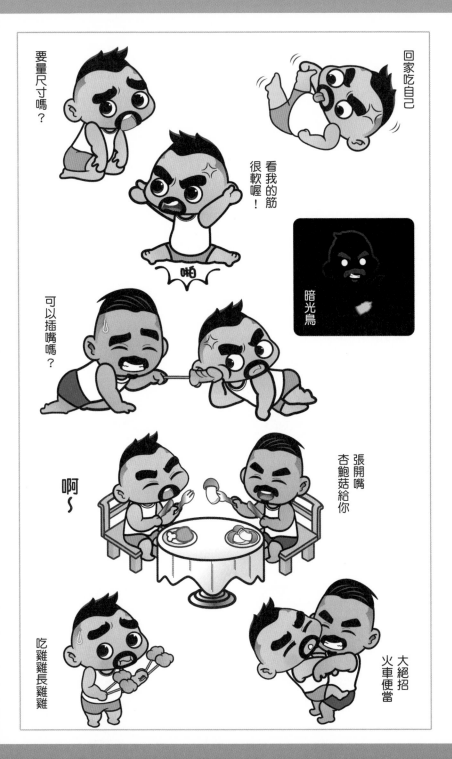

chapter

5

特別收錄
妄想小劇場

Spider...man?

蜘
蛛
…
人
？

Thank you for saving my life, you are my hero!

With great power comes great responsibility!

(OUCH...)

Well, I don't think you are overweight, you are just big-boned.

小叔
愛
工頭

118

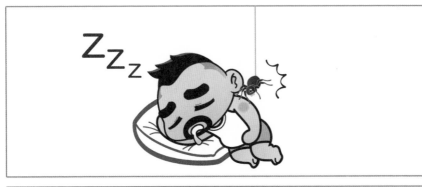

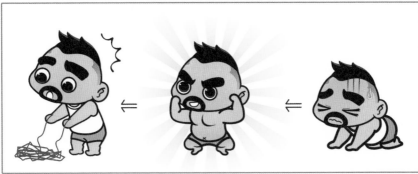

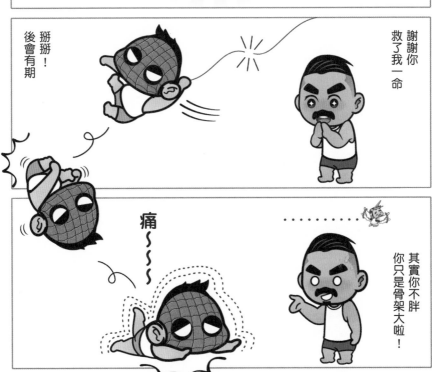

SLAP!

Stop! Go clean up those cobwebs. NOW!

Yes, sir!

小叔

愛

工頭

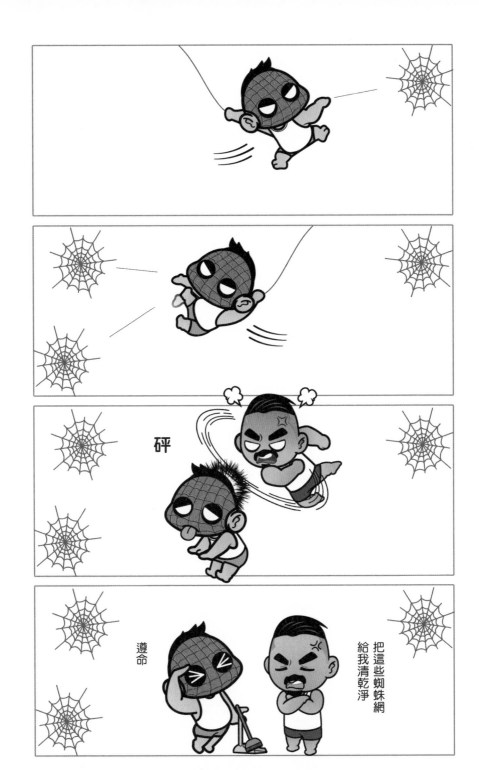

Rapunzel

長髮王子

Rapunsel, let down your hair to me!

Oh, here you come, my hero!

Oops, it that the hair I used to climbed up here?

Oh, my hero, that's my HAIR as well!

Seriously? Pubic hair!?

Bingo!

小
愛叔
工
頭

122

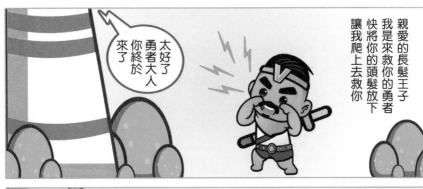

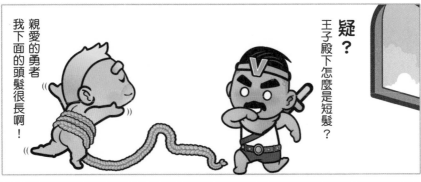

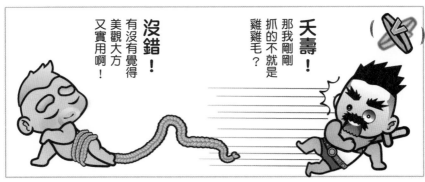

Ewww... I can't believe this, I've been tricked.

Oh, my hero, don't waste time, let's have some fun!

Well, I am leaving. Let's pretend that we've never met ever, okay?

DAMN! (Anger mode on)

HELP!

You had it coming. It's too late to regret!

Ha Ha Ha, I will drain you out!

工↓小
頭↑叔

124

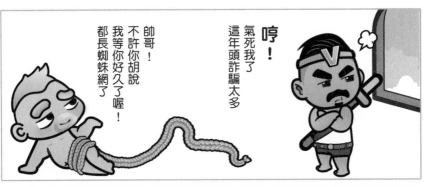

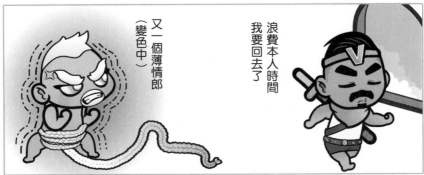

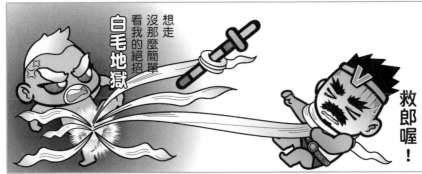

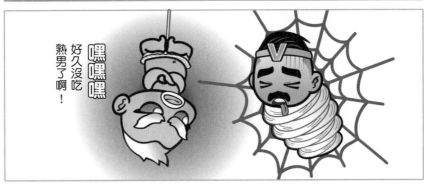

Plumber

水電工

SPLASH!

Hello, there's something wrong with my faucet, would you please come to check?

Hello, did you just call a plumber?

Uh... Yes, would you please check the faucet over there?

Thank you for coming quickly and fixing it!

No problem, I will handle it.

工頭 愛 小叔

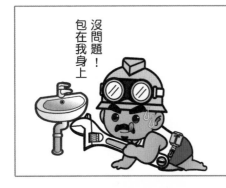

Anything wrong with the faucet again?

Well, not really...

There's something wrong with my pipe.

So... The man pipe needs to be cleaned?

It's emergency!

Sure I can handle it as well!

工_頭｜_愛｜小叔

上次的水龍頭
又壞掉了嗎？

不是啦

這次是我的
水管塞住了

是你還是水管
塞住了呢？

嗯哼！

都有啦！

The Grateful Crane

白鶴報恩

Croak~~~ Croak~~~ (I got hurt, it's painful!)

Croak~~~ Croak~~~ (Thank you)

I get a smelly hand-made scarf as the reward?

Croak~~~ Croak~~~ (Thank you, my hero!)

小叔
愛
工頭

130

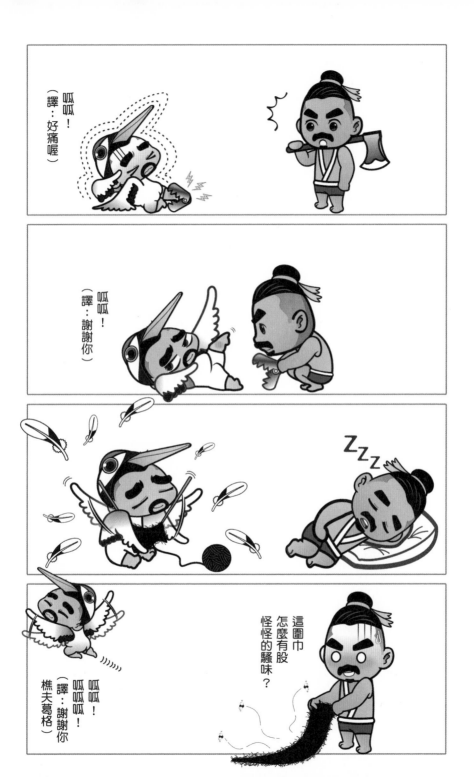

Fighters of
Mid-autumn Festival

中秋之決戰紫雞之顛

Tonight, you are my bottom.

You took my line.

High-calorie mooncake attack!

It doesn't work for me!

Sausage shuriken! (Shrimp boomerang!)

Well, it seems you can't be my bottom tonight...

Ah, I am allergic to shrimps!

小叔
愛
工頭

132

聽你在放屁

今晚乖乖地趴下吧！

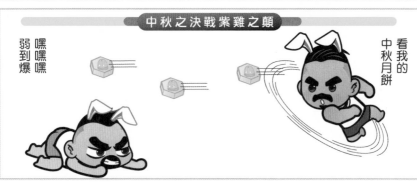

嘿嘿嘿弱到爆

看我的中秋月餅

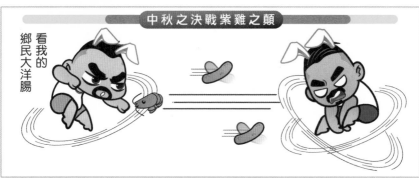

看我的鄉民大洋腸

唉唷！我過敏了啦！

對不起！你還好嗎？

Horus

老鷹精

What's bothering you?

I have no idea about the costume party.

Oh, what's the dress code?

Um, it's 'fantastic beasts'.

Don't worry sweetheart, you can count on me!

Sweetheart, you are always my hero!

Perfect! You are the fantastic man-eater!

The costume is nice but are you sure the name is okay?

小叔
工頭

怎麼啦？

煩死了！公司要辦什麼妖怪主題趴

嘖嘖嘖！這樣子啊！

蜘蛛精？白骨精？還是牛魔王？我腦袋空空的！

沒問題！包在我身上

我就知道！你是個值得我依靠的男人！

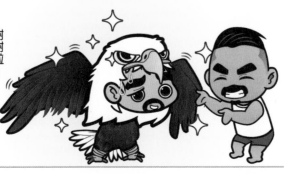

大功告成！這次的設計主題叫做「老鷹精」！

謝謝啦！不過怎麼聽起來怪怪的？

The Little Merman

腳美人魚

Once I drink this bottle of magic potion then I will have human legs! (magic potion)

Ah Ah Ah...

Hey, do you remember me?

Are you... the person who saved my life?

Well, the magic potion is more powerful than my expectation...

Gee, are you from the X-files?

小叔
愛
工頭

136

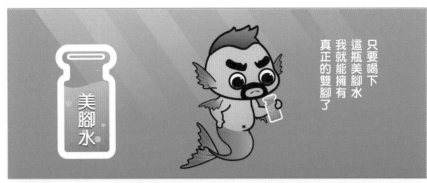

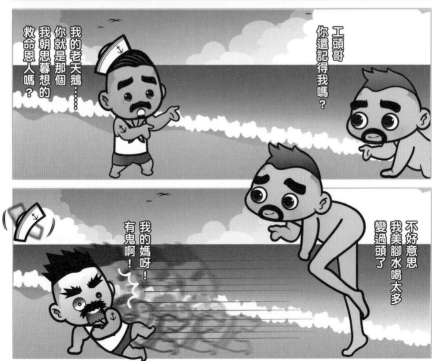

chapter

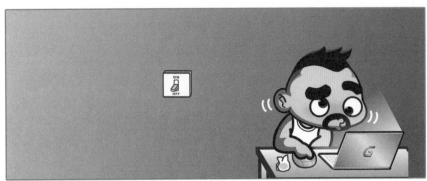

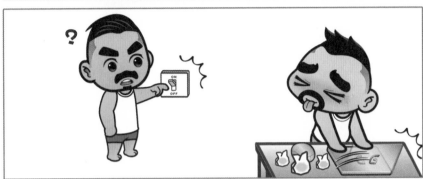

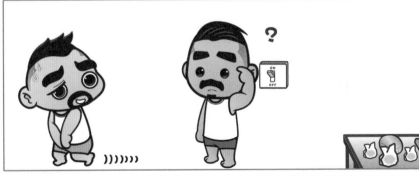

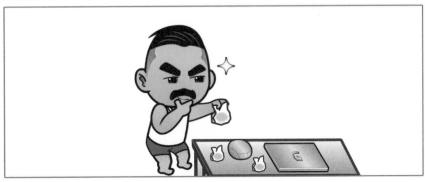

The Vibration Mode

震動模式

Sweetheart, are you ready to home?

(Riz... Riz... Riz...)

Here you go, wipe the sweat.

Youuu... arrr... sooo... niceee...

OH! The vibration mode is on!

Can I try this mode on me tonight?

SURE! And you have a lifetime warranty.

小叔
震
工頭

142

寶貝！我來接你下班囉！

咚咚咚 咚咚咚 咚咚咚 咚咚咚

你你你……真真真……好好好……

辛苦了！我來幫你擦汗！

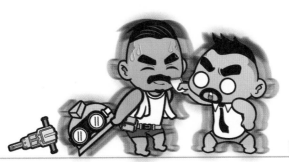

喔喔喔電鑽版的震動模式耶！

那麼今晚打洞也要開這個模式喔！

震動強度永不衰退永久保固喔！

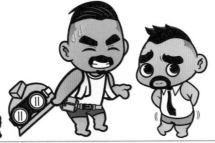

The Secret Therapy

治頭痛

Hey, sweetheart, you don't look well. What's wrong?

I have a strong headache, I am so sick!

I know a secret massage to cure headaches, you wanna try it?

Really? Just let me try!

Wow, it works! I do feel better now! But I feel something hard is under my head...

Oh... That's a secret tool for the advanced massage!

Oh, heaven, I'm in heaven!

Yes, it's your exclusive meat massager.

工頭 頭 小叔

144

頭痛！鬢邊嚇嚇叫！

寶貝！怎麼了嗎？看你臉色好差！

真的嗎？

我有絕招專治頭痛喔！

嘿嘿嘿！因為等等還有加強版的喔！

好酥福喔！但是頭後面怎麼有硬物頂著！

嘿嘿嘿！這是高級按摩棒啊！

喔喔喔

Wow, you look exhausted.

I had a tough day!

Come in my arms, sweetheart!

Hooray!

Um... I don't feel anything different... yet.

You will feel full-charged when I plug in the power stick~

工↓小
頭愛叔
↑

今天忙過頭
快累死人了！

累～～～～

怎麼了啊？

那快到我懷裡
充電吧！

歐耶！

有什麼差別？
還是一樣
很累啊！

那是因為
還沒插上
插頭啊！

Efficient Charging

Take care, sweetheart.

(YAWN...) Go to work honey.

You still look sleepy and tired.

Hey, we spent all night to clean out the pipe.

But the pipe still seems to be deep cleaned.

Can we do it afterward? I am almost late to work!

Well... Let's try my efficient way!

Um... Okay, maybe I can go to work later...

小叔
愛
工頭

出門上班
要注意安全喔！

啊～～～
那我出門了喔！

看來昨天
電沒充飽喔！

誰叫你昨天
要熬夜充電！

嘿嘿嘿！
要不要我幫你
繼續充飽電啊！

可是
我上班
快遲到了啦！

我還有一個
正在研發中的
快充模式

那我請半天假
好了！

Steps to make your lover recovering his energy

Step 1: Removing the clothing

Step 2: Massaging with love

Step 3: Taking a shower with his favorite shower gel

Step 4: Plugging in the power stick

Meow~~~

Can we just skip the first three steps?

小叔
工^愛頭

真是心疼……

除去外包裝

按摩軟化筋肉

料理豬肉小撇步

刷洗去腥味

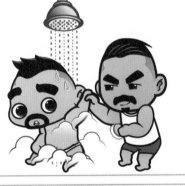

上菜囉

喵嗚～～～

難怪你這麼積極幫我洗澡

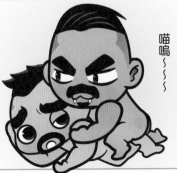

Dead Fish

今天吃素

Are you pretending that you are a dead fish?

LEAVE! ME! ALONE!

Errrr......

I don't have the mood today!

OUCH!

小叔
愛
工頭

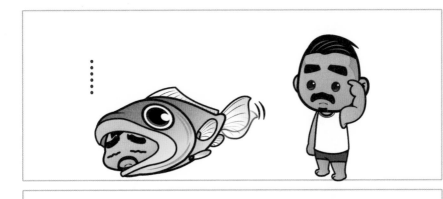

別理我！

幹嘛像一條
死魚一樣？

別碰我！
老子今天
下面吃素！

哀啊！

Some More, Please?

我還要

Determination is the key to lose your weight.

(CHEW CHEW)

And away from starch and snacks.

(Licking licking)

What are you eating?

You wanna some?

Gee, it's yummy! May I have some more?

Well... Where is your determination?

小叔
愛
工頭

154

減肥
最重要的就是決心！
（滔滔不絕）

嚼嚼！

要戒掉
澱粉、零食
還有醣類！
（繼續碎念）

吸吸！

你在吃什麼啊！

唔！給你

好好吃喔
我還要！

嗯哼！

Work Hard,
Play Hard

Why you stay so late? You need more sleep.

You need a bottle of Red Bull.

Thank you sweetheart.

Don't forget we need to clean out the pipe before sleep.

Okay, later!

WAIT! did he mean CLEAN OUT...THE PIPE LATER?

小叔
工頭
愛

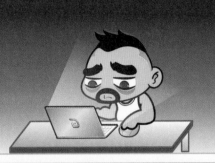

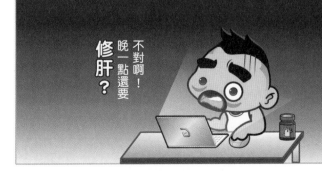

Take good care of yourself these 4 days during my business trip.

I will be lonely these days.

Don't worry, I have prepared some cucumbers, eggplants and king oyster mushrooms as the substitutes.

Come on, I need some FRESH MEAT!

Vegetables are good for you sweetheart!

工頭 愛 小叔

158

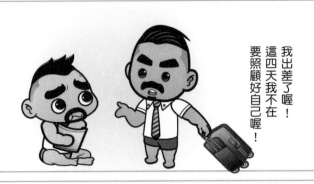

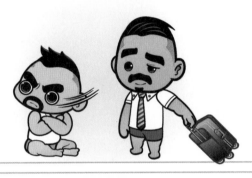

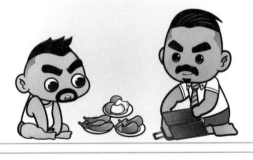

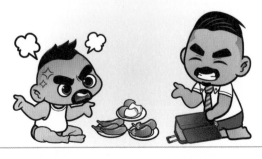

(Baby powdering...)

GEE~~!

Hey, don't use the baby powder when the fan is on!

I feel cooler now...

小叔
愛
工頭

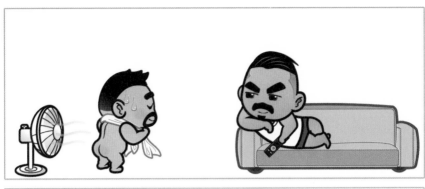

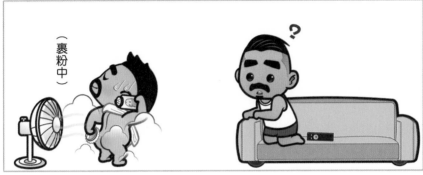

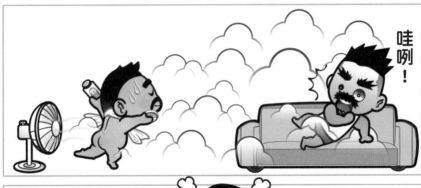

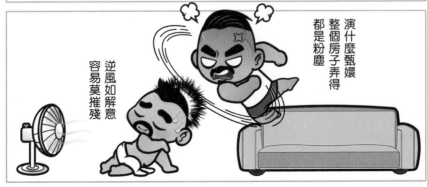

Housekeeping

Housekeeping mode on!

Do the laundry first.

And don't forget to clean out the garbage.

Sweetheart, you left the 'Mini-Me' at home!

No wonder I could not find it out anywhere!

工頭 小叔
愛

寶貝不在家
我不能偷懶

所有的髒衣服
都要洗乾淨

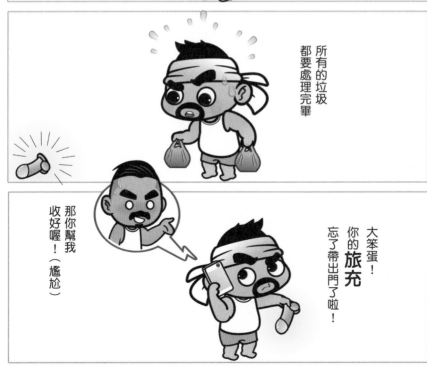

所有的垃圾
都要處理完畢

大笨蛋！
你的 **旅充**
忘了帶出門了啦！

那你幫我
收好喔！（尷尬）

Why you ate all fried chicken? Nothing left!

Sorry sweetheart, I was too hungry.

Let me do something to compensate for you!

This fresh meat sausage is all yours!

Always the old trick! It doesn't work this time!

Ouch!

小叔
愛
工頭

為什麼你每次都忘了要留一份雞排給我？

對不起！

你不要生氣啦要不然你看這樣好不好！

給你吃我的雞排吃到過癮喔！

又來了這一招每次都脫褲子

唉啊！

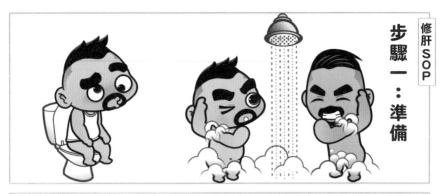

步驟一：準備

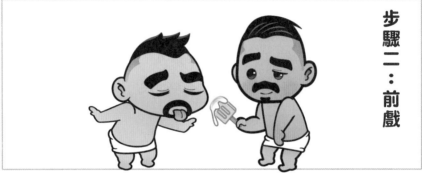

步驟二：前戲

The SOP for Having Pleasurable Sex

Step 1: Warm up

Step 2: Fore play

166

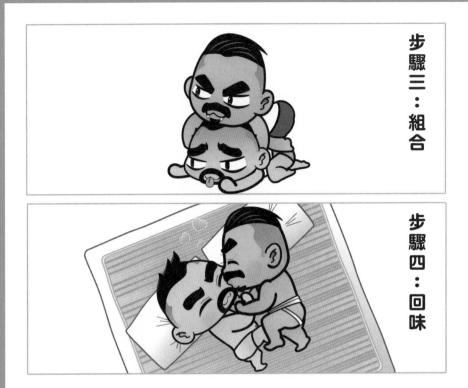

步驟三：組合

步驟四：回味

Step 3: Give and Take

Step 4: Review and Feedback

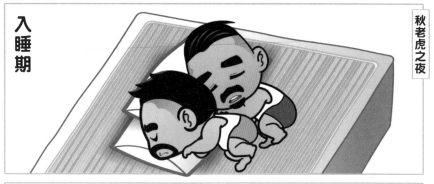

入睡期

脫衣期

The Indian Summer Night

Good night and sleep tight

The less you wear, the cooler you feel

顛倒期

擁抱期

Up side down

Dream a little dream of you

chapter

Promise Me

答應我

Will you cheat on me if I am far away from you?

Cheating is not related to the distance, sweetheart!

So, will you cheat on me?

Could you ask anything else?

Why don't you answer my question?

Come on, why are you so serious?

HUMPH!

Sweetheart, don't be so mad! Don't worry about things never happens.

小叔
工愛
頭叔

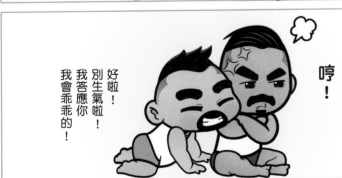

You Are Not Here

你不在

HA HA HA HA HA

Look, sweetheart, this is my favorite scene in this movie!

............

Oh... I forget you are not here with me these days.

工頭 愛 小叔

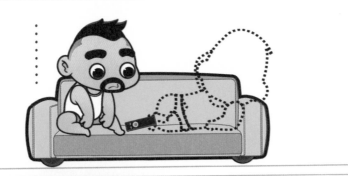

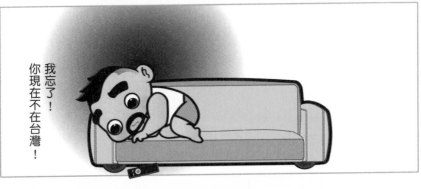

Say Sorry

寶貝對不起

STOP! I don't wanna talk to you. You are so irrational!

Why are you so stubborn?

We are totally done this time! I can't stand him anymore...

I told you that he is such an A HOLE!

(Did I go too far? Am I too stubborn to take any suggestions?)

I'm sorry for saying you are irrational.

I'm sorry too. I didn't mean it.

小叔
愛
工頭

176

我聽你在放屁！

咧～～～

我是為你好
你怎麼那樣固執
講也講不聽！

早就勸過你
像他脾氣這樣差
不值得你這樣付出
＊＄＠＃＆＊＠
％＠＃＄！＊

我跟你說
這次工頭
超級過份的
％＄＆＊＠＃
＊％＆＃％
＠％！

（我好像
說得太過頭了）

寶貝對不起！
我好壞好過份
你對我真的很好！

我也跟你說
對不起！
是我的脾氣
太差了！

Don't stay up too late, sweetheart.

Yes, sir!

小叔
工愛頭

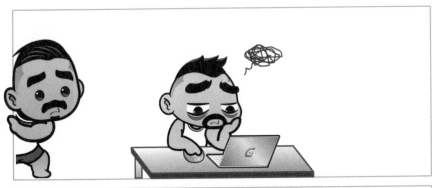

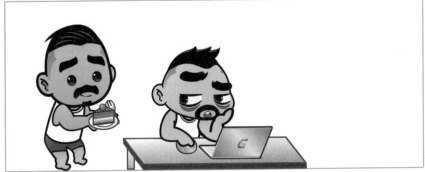

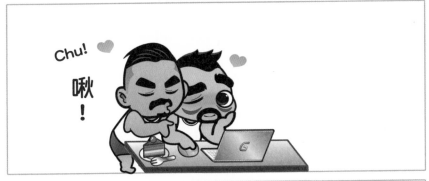

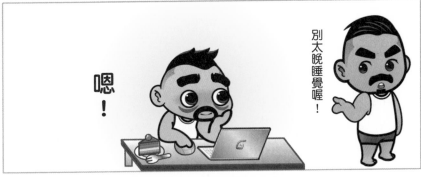

Love Song

情
歌

Those photos keep the good memories of us.

Yup, the happy memories pop up in my mind again.

Do you remember the camping?

SURE! Our first camping at the creek.

And you remember the song as well?

HEE HEE HEE

You mean that one?

Cause tonight is the night when two become one. –
2 Become 1, The Spice Girls.

小
叔
愛
工
頭

Holding Hands

牽手

小叔
工愛頭

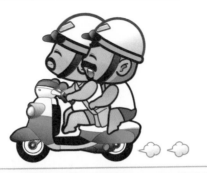

騎機車時

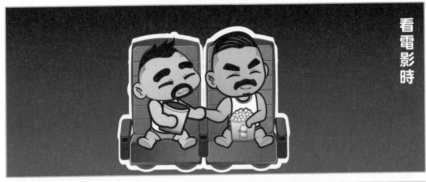

看電影時

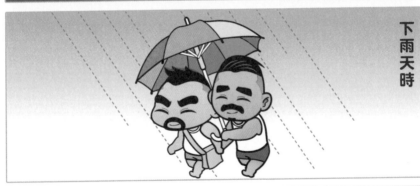

下雨天時

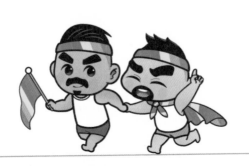

遊行時

itchy...

Feel better?

Yup, better now. Thank you sweetheart.

Sweetheart, I am going to work abroad since this winter and I will not scratch you as often as now.

Sooner or later you would come back to me, right?

工↓小
頭愛叔

184

癢~~~

我來幫你
抓抓癢

謝謝你
舒服多了

寶貝！今年冬天
我就要出國工作
不能常常幫你
抓背了喔！

！

沒關係！
先給你欠著
我會坐飛機過去
找你要回來！

Terminal 1, Taoyuan International Airport

Take good care of yourself when I am not stand by your side.

We'll be apart at most three years. Please be patient with the period of time.

Oh, gosh, I really don't wanna you go.

工頭 愛 小叔

186

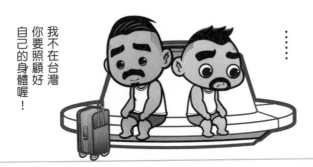

…………

我不在台灣
你要照顧好
自己的身體喔
！

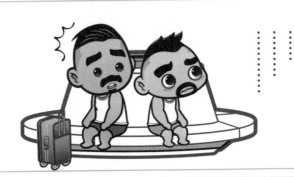

…………

頂多打拚
二到三年
我會儘快回來
你要等我喔
！

…………

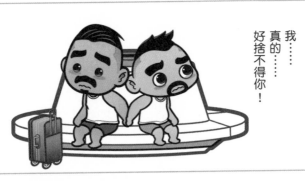

我……
真的……
好捨不得你
！

I'm Feeling You Everywhere

感覺著你，每一天

Sweetheart, I can still feel you everyday. How much I miss you.

小叔 愛 工頭

小叔愛工頭

後記

突然間小叔不知道
該怎樣把20年的感情
濃縮成幾行字丟到紙上
想說的爭先恐後　好難

午後雷陣雨的清爽
讓人腦袋瓜暫時不當機　可以思考

這系列的漫畫
是為了記錄與紀念
小叔跟工頭牽手這麼多年
很幸運　也很不容易

那一起走過的許多點滴

是個不斷向內扒光的過程

如人飲水　點滴自知

提醒我們　愛依然縈在彼此的心頭　很深

但也會在我們無助時　給一點力量

往事從來沒有那樣容易地　放過自己

好幾次的回憶　畫得自己鼻酸

很慶幸一路有你們的陪伴與支持

謝謝　真的謝謝

也很高興　這輩子　能跟你在一起

寶貝　有你真好

332661314

——小叔

男事繪系列 編號 F005

小叔愛工頭

圖 · 文	小 叔	
英 譯	李偉台	

責任編輯	邵祺邁
封面設計	Winder Design
內頁構成	Winder Design

企劃製作 基本書坊

社 長	邵祺邁
法律顧問	維虹法律事務所 鄧傑律師
業務副理	蔡立哲
首席智庫	游格雷

社 址	427 台中市潭子區合作街 114 號
電 話	04-25361210
官 網	gbookstaiwan.blogspot.com
E-mail	pr@gbookstw.com

總 經 銷	紅螞蟻圖書有限公司
地 址	114 台北市內湖區舊宗路二段 121 巷 19 號
電 話	02-27953656
傳 真	02-27954100

2018 年 9 月 15 日 初版一刷

定 價 新台幣 320 元

ISBN 978-986-6474-76-7

國家圖書館出版品預行編目 (CIP) 資料

小叔愛工頭 / 小叔著 . -- 初版 . -- 臺中市 : 基本書坊 , 2018.09
192 面 ; 15 * 21 公分 . -- (男事繪系列 ; F005)
ISBN 978-986-6474-76-7(平裝)

1. 漫畫

947.41 107012810